T0017214

SEARCHING FOR Seashells

SEARCHING FOR

Seashells

AN ARTIST'S GUIDE TO TREASURES ON THE BEACH

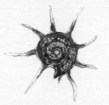

JESSIE KING REGUNBERG

WORKMAN PUBLISHING • NEW YORK

Workman
Workman Publishing
Hachette Book Group, Inc.
1290 Avenue of the Americas
New York, NY 10104
workman.com

Workman is an imprint of Workman Publishing, a division of Hachette Book Group, Inc. The Workman name and logo are registered trademarks of Hachette Book Group, Inc.

Design by Sarah Smith

The publisher is not responsible for websites (or their content) that are not owned by the publisher.

Workman books may be purchased in bulk for business, educational, or promotional use. For information, please contact your local bookseller or the Hachette Book Group Special Markets Department at special.markets@hbgusa.com.

Library of Congress Cataloging-in-Publication Data is available.

ISBN 978-1-5235-2345-0

First Edition April 2024

Printed in China on responsibly sourced paper.

10 9 8 7 6 5 4 3 2 1

For my mother,
who taught me always to look down,
because you never know what treasures
you'll find for your collections.

Contents

Introduction . VIII

Meet the Mollusk . 2

Top Shells .16

Limpet Shells . 18

Tun Shells . 24

Murex Shells . 25

Conch Shells . 30

Oysters . 33

Triton Shells . 38

Harp Shells . 40

Screw Shells . 42

Tulip Shells . 43

Vase Shells . 44

Drupe Shells . 46

Bonnet & Helmet Shells . 47

Clams . 48

Mussels . 54

Cockles . 55

Bubble Shells . 58

Spindle Shells . 59

Turban Shells . 60

Cone Shells . 64

Latiaxis Shells . 66

Star Shells . 68

Cowrie Shells . 72

Nerite Shells . 76

Fig Shells . 77

Sundial Shells . 78

Chambered Nautilus . 80

Turrid Shells . 84

Abalone Shells . 85

Auger Shells . 86

Noble Pen Shell . 87

Carrier Shells . 92

Creeper Shells . 93

Worm Shells . 94

Periwinkle Shells . 95

Scallops . 98

Deep-Sea Snails . 102

A Collector's Guide . 112

Acknowledgments . 118

About the Author . 120

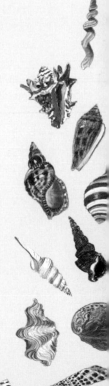

Introduction

As a child, I spent my time at the beach combing for treasures and marveling at the beauty and diversity of seashells. Upon each visit, my brother and I would insist on schlepping home buckets of shells, eventually amassing a giant collection of mostly broken pieces in our craft corner. Throughout the year we would use these tiny treasures to create art, build castles, and reminisce about our competitive shell-collecting on the shore. As an adult, I've been thankful there exists a creature that consumes so much of my own children's time and energy, leaving me the space necessary for quiet beach reading. And yet I usually still find myself stretching their tiny snorkels over my adult-sized head to wonder at and collect seashells in the shallow shoreline. Though I'm now more discerning about which shells I keep, I still maintain a sizable collection in my art studio. I've used these shells in my mosaic work and as objects to draw and paint, and always as reminders of the serenity and joy of the ocean. But it was not until I began researching this book that I truly fell in love with the seashell and its shocking influence on our world.

Having trained as a historian, I found it increasingly impossible to ignore the place of the mollusk in history and its influences on fields as diverse as art, cuisine, music, and evolution. After all, seashells and the animals within them have occupied people's imaginations and realities from the earliest periods of recorded history. Greek philosopher Aristotle, in fact, coined the term *molluska*, meaning "soft-bodied." How could I honor the allure of seashells without paying tribute to their far-reaching contributions to human development? And so a book dedicated to the life and story of the seashell was born—a biography of seashells, if you will.

There are more than two hundred thousand species of mollusk, and each is important and unique. But this book is not organized like a scientific guide; the shell families highlighted in the pages ahead—chosen for their aesthetic brilliance or novelty—compose only a tiny fragment of the shell world. Alongside them you'll find facts and anecdotes that will surprise. (Did you know that beach sand is made up of coral and shells? When seen under a microscope, that seemingly white or yellow powder that makes up your sandcastle might be composed of entire tiny shells!) You will also find more than two hundred seashell paintings, rendered to do as much justice to the shells' natural beauty and variety as I could muster with paint and paper. Admire the vibrant colors of top shells on one page, and learn of the seashell's impact on architecture on another.

My hope is that as you explore this book, you will gain a deeper appreciation for seashells, the animals they house, and their influences on your life. I, certainly, will never see the world as I did before making this book.

Meet the Mollusk

Every shell you've ever picked up and marveled at while walking along the water's edge once housed a particular mollusk, or soft-bodied, legless invertebrate. Mollusks are one of the largest and most diverse groups of animals on Earth. They live in damp environments, on land or in the water, in fresh water and salt water, all throughout the world.

There are five main classes of mollusks (this book mostly focuses on the diversity and beauty of the two largest groups, Gastropoda and Bivalvia, though there are examples from the other classes as well):

GASTROPODA

Also known as snails, gastropods have a single shell that is usually coiled in shape. The animal has a head with tentacles and a radula, or rasping tongue. The large shells you put to your ear as a child to hear the ocean are gastropods. (Slugs are also included in this class, but they, of course, don't have shells.)

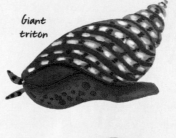

Giant triton

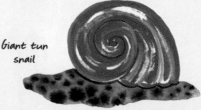

Giant tun snail

BIVALVIA

These mollusks have two valves joined by a hinge, a horny ligament, and muscles. Much of the shellfish we consume, such as oysters, clams, and mussels, are bivalves.

Atlantic giant cockle

POLYPLACOPHORA (AKA CHITONS)

Chitons have plated shells that are embedded in tough tissue. From overhead, these seashells resemble an armored shield.

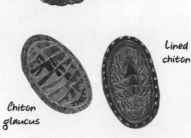

Lined chiton

Chiton glaucus

SCAPHOPODA (AKA TUSK SHELLS)

Tusk shells are curved and tooth-like with an opening at each end. They can vary in size but are not particularly diverse in other characteristics like color and shape.

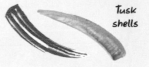

Tusk shells

CEPHALOPODA

Cephalopods are a confusing class of mollusk, as only about six different species have external shells. All shelled cephalopods are members of the nautilus family. However, squid, octopus, and cuttlefish are also cephalopods, though these animals possess no outer shell.

Nautilus

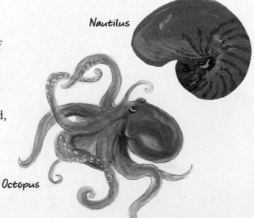

Octopus

Mollusk Anatomy

But what exactly are shells? And how are they made? Shells are composed of calcium carbonate and conchiolin, the same protein that is found in the gastropod's operculum. (The ancient Greeks were known to brush their teeth with crushed oyster shells, as the calcium carbonate was an effective cleaning abrasive. Today's commercial toothpastes still rely on this same compound!) The thin, fleshy mantle—the layer immediately underneath the shell—secretes these materials in layers, which form the hard shell. The shell gains its strength from this layered, piecemeal growth. Sometimes the matter that makes up a shell also produces a beautiful nacre (also known as mother-of-pearl).

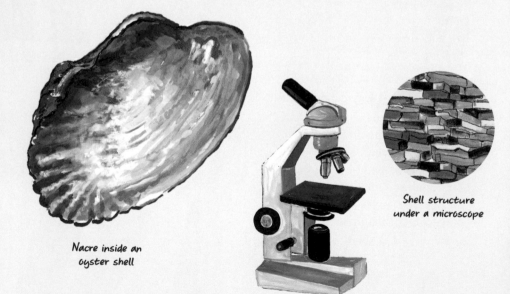

Nacre inside an
oyster shell

Shell structure
under a microscope

GASTROPOD

The word *gastropod* is Greek for "stomach foot" and is derived from the anatomy of snails. These creatures have a broad, flat muscle—or "foot"—that they use for support and movement. The foot runs along the snail's base, or belly. Mature snails also develop eyes and a proboscis, a long, tubular sucking organ. The operculum is a plate that the snail uses to cover its aperture when the animal withdraws inside its shell.

BIVALVE

The two shells of a bivalve are called valves. The mantle is the layer of tissue between the shells and the animal's body. Unlike snails, they do not possess a head or radular teeth. Instead, they have gills that help them feed. The foot can retract into the valves, but the shells are usually kept a tiny bit open with an elastic, horny pad (the hinge).

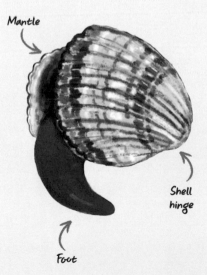

Proboscis

Operculum

Foot

Mantle

Shell hinge

Foot

Seashells are not composed of living cells. If you've ever seen the underside of a turtle shell, you know that it is attached to and grows with the animal's skeleton. That means it has living cells, blood vessels, and nerves dispersed throughout. Seashells, on the other hand, are the exoskeletons of mollusks—they are in contact with but not attached to their shells. Therefore, when a mollusk's shell is damaged, it does not directly hurt the animal.

DEXTRAL

Most gastropod shells open to the right, or clockwise. These are called dextral shells. For the most part, "right-handed" snails can only mate with other "righties" and vice versa.

Pontifical mitre

Atlantic knobbed whelk

Spider conch

SINISTRAL

Only 1–5 percent of coiled shells open to the left, or counterclockwise. Florida lightning whelks are the only type of snail species whose shells regularly open to the left. They are found in marine waters along the southern Atlantic coast.

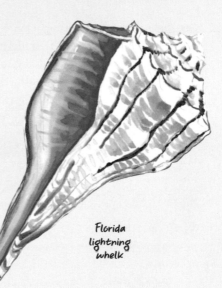

Florida lightning whelk

And you think finding a mate is hard? Imagine scouring the ocean to find your left-handed soulmate.

What's in a Name?

Like all living animals, each shell is classified within the Linnaean system under its Latin or scientific name. Unlike the common names used in this book—which, though more fun, can vary in different languages and countries—a shell's scientific name remains constant. The naming of each species follows a particular structure, with two Latin names. The first name refers to the genus (the group to which the species belongs) and always starts with a capital letter. The second, uncapitalized word is the specific name of the species and is often derived from the scientist who first publishes a thorough description of the species.

COMMON NAME: Giant keyhole limpet

PHYLUM: Mollusca

CLASS: Gastropoda

SUBCLASS: Vetigastropoda

ORDER: Lepetellida

FAMILY: Fissurellidae

GENUS: *Fissurella*

SPECIES: *Fissurella maxima*

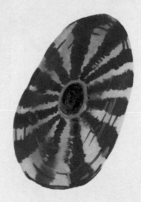

Giant keyhole
limpet

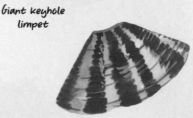

The Slimy Truth

So, what's the deal with snail slime? Gastropods secrete a watery gel-like mucus from glands all over their bodies. The slime contains glycoprotein polymers—large, complex molecules that link together to give slime its stretchy, gooey texture. When resting, snails use this mucus to glue themselves to a substrate, creating a seal to cover their opening. This allows the snail to stay moist and protected.

Medical researchers are studying snail slime in hopes of developing new surgical glues that can bind wet, moving tissues. It is also used in beauty products: Besides water, snail mucus is composed of some powerful skin-care compounds such as hyaluronic acid, collagen, elastin, glycolic acid, antimicrobials, and natural UV protection. These compounds are said to moisturize, exfoliate, and reduce signs of aging.

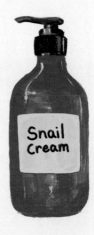

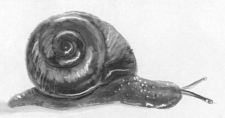

In real life, snail slime is mostly clear.

Shells and Evolution

A mollusk's age can be determined by using a microscope to count the growth lines in its shell—just like counting the rings in a tree trunk! Scientists can also analyze the ratio of oxygen and carbon in a shell to deduce the sea temperature and salt levels at the time each ring was formed. The amounts of other elements in a shell can be compared to current concentrations to shed light on marine pollution and changes in the ocean over time.

Close-up of an oyster shell

Ammonites were around during the time of the dinosaurs and were once the most abundant animals in the ocean. They went extinct sixty-six million years ago and have been preserved as fossils all over the world. They were cephalopods, like squid and octopus, but had a shell like the modern-day nautilus.

Ammonite fossils

What a living ammonite may have looked like

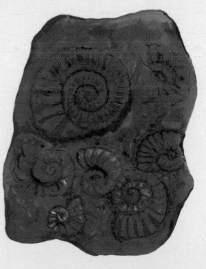

Home Is Where the Shell Is

There are about one hundred kinds of mollusks that live on or near the surface of the ocean. Some, like the common purple snail, float; some attach themselves to seaweed; and still others hover just underneath the surface.

Pelagic zone

Littoral zone

Also called the intertidal zone, the shoreline is home to thousands of the world's mollusks. Often the easiest shells to collect, these animals live in the space between high and low tides.

Shallow waters

The majority of marine mollusks make their homes on the continental shelves—where the land extends underneath the water—and in the coral reefs. The abundance of animal and plant life in these regions supports a diverse population of mollusks.

The deep, dark waters of the abyssal zone are home to many small, mostly colorless species of mollusks. Several types of unshelled cephalopods, such as squid, also inhabit this cold zone, where sunlight barely reaches.

Abyssal zone

Sea Shell

AMY LOWELL (1912)

———

Sea Shell, Sea Shell,
Sing me a song, O Please!
A song of ships, and sailor men,
And parrots, and tropical trees,

Of islands lost in the Spanish Main
Which no man ever may find again,
Of fishes and corals under the waves,
And seahorses stabled in great green caves.

Sea Shell, Sea Shell,
Sing of the things you know so well.

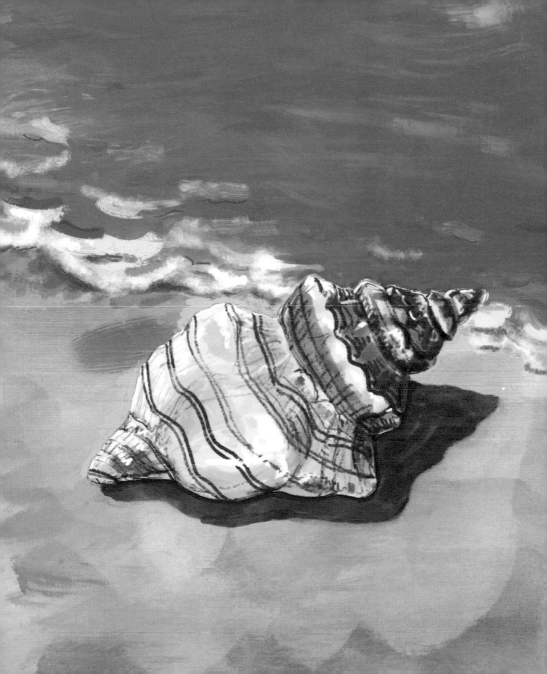

Top Shells

Top shells, named for their perfectly conical shape, live along rocky shores. The main ingredient of a shell—calcium carbonate— is white, so color comes from external factors in the mollusk's environment: the waters where it lives and the diet it ingests. This is why the most colorful shells are typically found in warmer waters, which support more diverse food sources for the mollusk than colder waters. The strawberry top, one of the world's most vibrant shells, is usually found on the shores of the Indian Ocean.

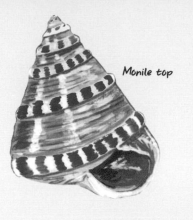

Monile top

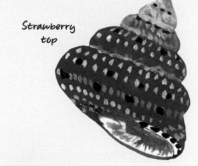

Strawberry top

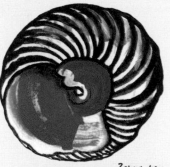

Zebra top

Pellucid maurea top

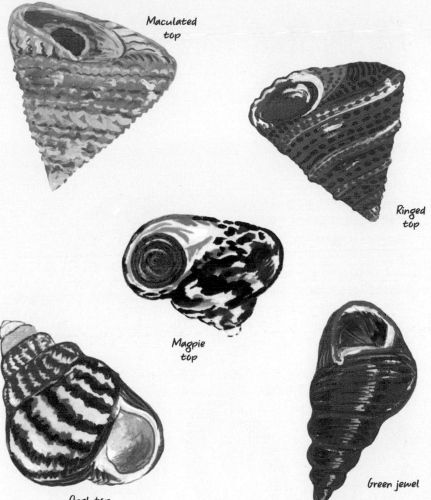

Maculated
top

Ringed
top

Magpie
top

Opal top

Green jewel

Limpet Shells

Limpets are small, flattened cones that accumulate on rocky shores in rough waters. Their shape is perfect for resisting the force of crashing waves. Perhaps surprising for such a small animal, limpets exhibit homing behavior, in which the snails follow the pheromones left behind in their trail of slime to find their way back to their chosen spot.

Limpet teeth are made out of the strongest organic material on Earth, surpassing even the strength of spider silk. If you had to scrape your teeth over rocky surfaces to eat every day, your teeth would be strong too!

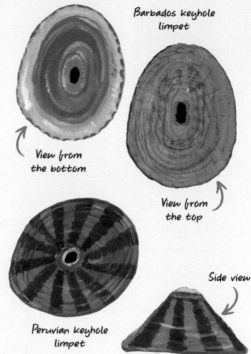

Barbados keyhole limpet

View from the bottom

View from the top

Peruvian keyhole limpet

Side view

Variable scurria

Giant owl limpet

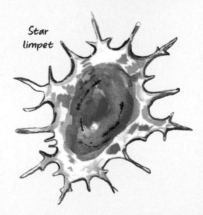

Star limpet

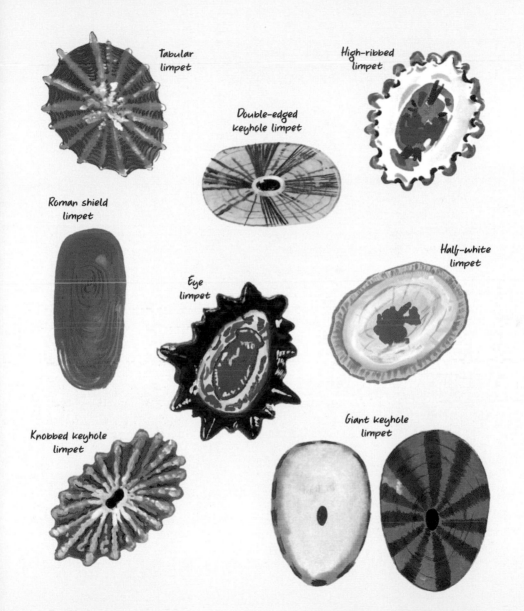

Tabular
limpet

High-ribbed
limpet

Double-edged
keyhole limpet

Roman shield
limpet

Half-white
limpet

Eye
limpet

Knobbed keyhole
limpet

Giant keyhole
limpet

The Art of the Shell

Given the natural beauty, mystery, and versatility of seashells, it is no surprise that art history is replete with references to gastropods. Shells have come to possess a vast number of meanings in Western and non-Western religious and secular art.

In cultures around the world, the shell is associated with the origin of life, and its resemblance to female genitalia has tied the seashell to fertility. Since the Middle Ages, the Virgin Mary has often been depicted in front of a half shell, symbolizing her divine conception. In seventeenth-century Europe, seashells from faraway lands were common objects in the portraits of prominent men, as they represented the wealth and power associated with their expanding empire and colonization. It was also not unusual for men to commission paintings of their expensive shell collections.

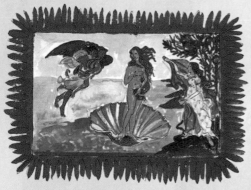

The Birth of Venus,
Sandro Botticelli, 1480s

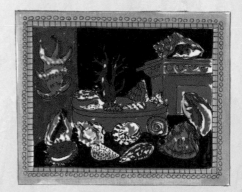

Still Life with Shells and Coral,
Jacques Linard, 1640

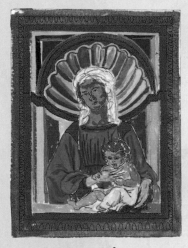

Madonna and Child,
Fra Filippo Lippi, 1440

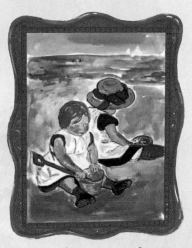

Children Playing on the Beach,
Mary Cassatt, 1884

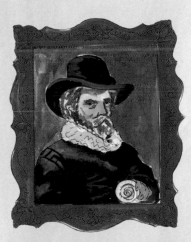

Portrait of a Man with a Shell,
Thomas de Keyser, 1625-26

Umi no sachi (The Bounty of the
Sea), Katsuma Ryusai, 1778

The shell has lent its form to design and ornamentation since humans first began creating tools and instruments. The Greek flask and Roman oil lamp here are enhanced with shell designs, which are powerful evidence of humanity's impulse toward art and beauty. They also suggest that human craft has always been influenced by the natural environment.

Over time, seashell art has developed meaning beyond ornamentation. The cowrie shells adorning the mask below, for example, symbolized social status and power, as these shells were entangled in the development of trade and early capitalism.

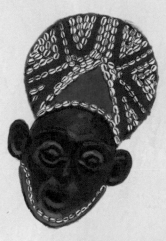

Helmet mask decorated
with cowrie shells,
Bamum Kingdom,
c. before 1880

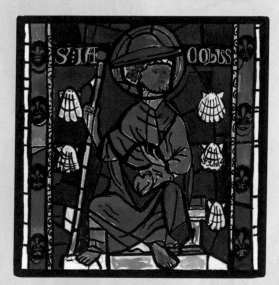

Detail of stained glass at Chapelle du Chateau
depicting St. James, from Rouen, Normandy,
fourteenth century CE

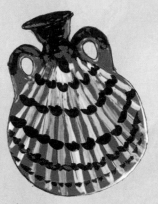

Greek terra-cotta flask,
fourth century BCE

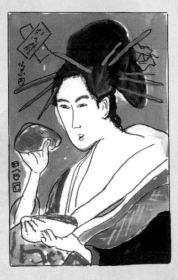

Matching Shells (Kai-awase), "Kisen Hōshi,"
from the series Modern Parodies of the Six Poetic
Immortals (Yatsushi rokkasen: Kisen Hōshi),
Chōbunsai Eishi, 1796–98

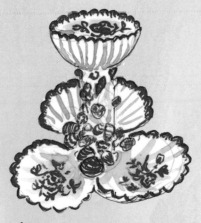

American pickle stand, manufactured
by American China Manufactory,
Gousse Bonnin, 1770–72

Roman terra-cotta oil lamp,
first century BCE

Tun Shells

Tun shells are a family of very big sea snails, the largest of which can reach up to six inches. The shape of these shells resembles the large wine vessels called tuns.

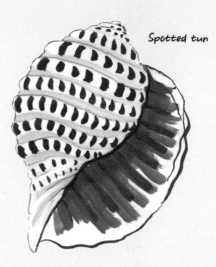

Spotted tun

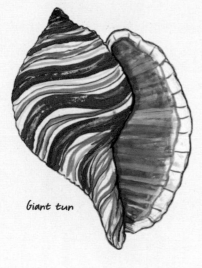

Giant tun

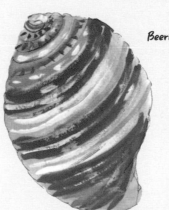

Beerbarrel tun

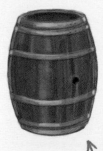

Wine tun

Murex Shells

Murex are rapacious predators. They eat other mollusks by secreting an acid that softens the shell of their prey. The murex then uses its radula—a tongue-like appendage—to drill an opening and suck out the meat. When beachcombing, you might find a shell with mysterious small holes—quite possibly the remnants of a murex's delicious meal!

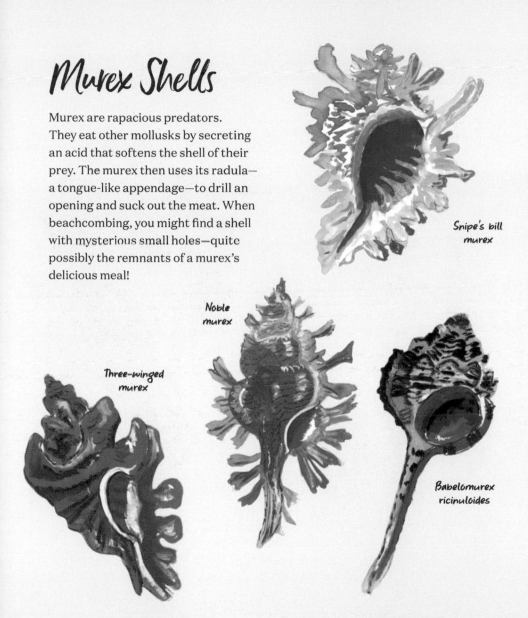

Snipe's bill murex

Noble murex

Three-winged murex

Babelomurex ricinuloides

There are several types of murices that, when threatened, eject a fluid that turns purple (also known as Tyrian purple) once exposed to the sun. Beginning in the sixteenth century BCE, this liquid was extracted from the gastropod to color garments. But the process was expensive—more than ten thousand snails and hours of manual labor were needed to harvest just one gram of dye. Because of this, eventually purple dye was reserved by law only for members of the highest ranks in Britain and many parts of Europe.

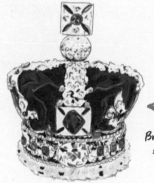

British imperial state crown

Purple dye murex

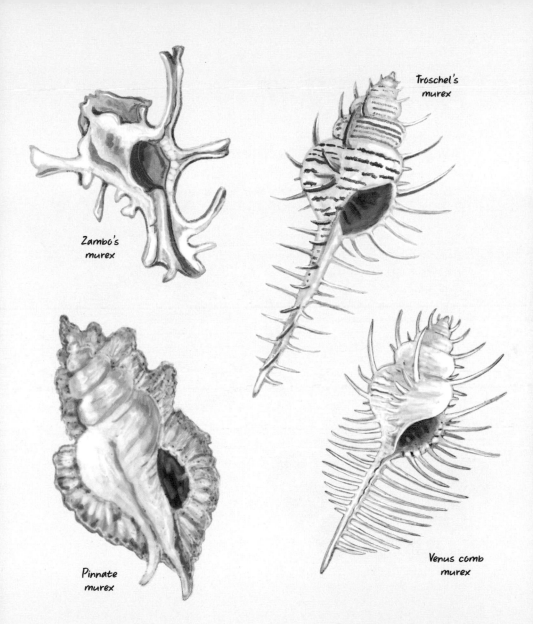

Zambo's
murex

Troschel's
murex

Pinnate
murex

Venus comb
murex

Prehistoric Shells

Seashells and the animals within have occupied people's imaginations and realities since the earliest periods of recorded history. Collections of seashells have been excavated from the ruins of Pompeii; some of the specimens came all the way from the Red Sea, and researchers believe they were kept for no purpose other than their natural beauty.

In the 1890s, researchers in Java, Indonesia, discovered a fossilized shell that functioned as a canvas for what they believe is evidence of the very earliest art. The 540,000-year-old shell features a geometric carving made by an ancestor to the human.

Between 2014 and 2018, archaeologists in Morocco unearthed thirty-three shell beads that date back 150,000 years. The holes in the center of these shells indicate that they were strung together or hung from clothing.

This ancient conch shell was found in a cave in the French Pyrenees in 1931. It is the oldest known wind instrument, dating back eighteen thousand years to the Paleolithic period. The tip, which is the strongest part of a shell, was broken purposefully to create a blowhole for the instrument. Hematite (a red pigment used in cave paintings) decorates the inside of the horn.

Indigenous to the Caribbean, this thousand-year-old, beautifully decorated conch was traded across thousands of miles and ended up in Chupícuaro, Mexico.

Conch Shells

Conch (pronounced "conk") shells are usually relatively large and elegantly decorated. As conchs age, their shells thicken. If you've ever held a heavy conch, you can bet the snail it housed lived to a ripe old age.

The largest of these gastropods are female. Like other gonochoric (having male and female sexes) snails, however, the male usually has a rounder opening to accommodate the extension of his penis during copulation.

Lister's conch

Broad Pacific conch

Little bear conch

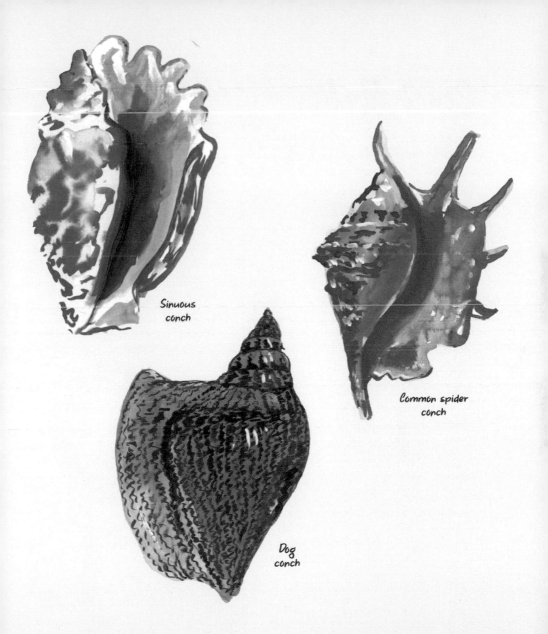

Sinuous
conch

Common spider
conch

Dog
conch

No doubt you've put a large shell to your ear to "listen to the sea." It was likely a queen conch whose "waves" you heard. The hard, curved interior of this shell amplifies the sound of air bouncing off its walls. The queen conch is also the perfect shape for . . . boxing! These shells were used for hundreds of years in Mesoamerica as boxing gloves. Ouch!

Queen conch

Cameos are carved from queen conch or helmet shells whose inner and outer layers of shell are different colors and are therefore perfect for this bicolored form of miniature relief. Though cameos were first carved in ancient Egypt, they were popularized in the nineteenth century by Queen Victoria.

Oysters

Oysters are a common type of bivalve that humans have eaten and cultivated for thousands of years. Oysters are not the only mollusk to produce pearls, but they are the species we most often associate with them. Pearls are formed when a foreign object gets stuck inside the living animal; the mollusk reacts by covering the irritant with more of its shiny inner shell, or nacre, creating a pearl around the object.

Perhaps even more impressive, oysters can filter up to 1.3 gallons of water per hour through their gills, consuming food like plankton in the process. Through this filtration, oysters help maintain the equilibrium of marine ecosystems by reducing excess algae, keeping alive animals that might otherwise suffer amid low oxygen levels.

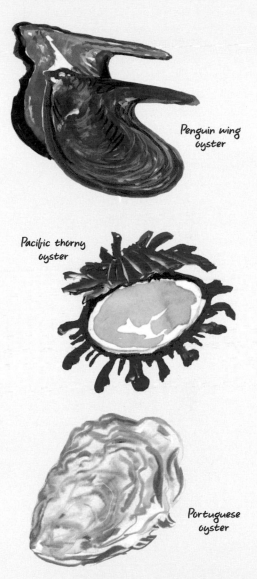

Penguin wing oyster

Pacific thorny oyster

Portuguese oyster

Oysters get their shape—and taste!—from their environment. After attaching to a hard surface, the oyster grows around this "bed." And because oysters take in so much water, their surroundings are responsible for the many flavors appreciated by foodies around the world.

cockscomb oyster

European flat oyster

Diving for Treasure

Japanese pearl divers—or ama, which translates to "woman of the sea"—specialized in free diving as deep as thirty feet to gather shellfish, seaweed, and pearls. Amas traditionally wore nothing more than a loincloth in the cold ocean water. They trained to hold their breath for up to two minutes at a time and would dive and scavenge for up to several hours a day. Demand for amas increased in 1893 when Mikimoto Kokichi discovered how to produce cultured pearls. Mikimoto employed amas to collect oysters, plant the pearl-producing irritants, and then return the animals to the seabed until the pearls were ready to be gathered.

Japan: The Ama Diver
Princess Tamatori Pursued
by a Ryujin or Japanese Sea Dragon,
Utagawa Kuniyoshi (1798–1861)

Shimmer and Shine

Wampum is a traditional shell bead made and used by many eastern tribes of Native Americans. Typically crafted from quahog and whelk shells, the beads are strung together and used as gifts, for storytelling, and as a way to record important events. When European colonizers arrived, they understood and adopted wampum as a form of currency to advance their own capitalist agenda.

Oyster shell pendants like this one from the Twelfth Dynasty of the Middle Kingdom in ancient Egypt, pierced with two holes in order to be strung and worn around the neck, were inscribed with a royal name. Scholars are unsure of the purpose of these pendants, but many have been found buried with or in some way connected to military personnel, leading some to believe these pieces were worn by soldiers.

Ancient Egyptians believed cowrie shells to be symbolic of many things, such as fertility, wealth, and sight. Girls and young women often wore girdles made of cowrie shells to protect their fertility, and pregnant women wore them to ensure healthy pregnancies.

Cowrie shells have also been found placed over the eyes of mummies in order to guarantee the dead's sight in the afterworld.

Triton Shells

In Greek mythology, Triton—son of Poseidon—is the god of the sea. He is often depicted blowing a large shell, which he uses to control the tides.

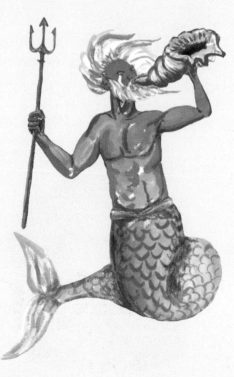

Lesser girdled triton

Magellanic triton

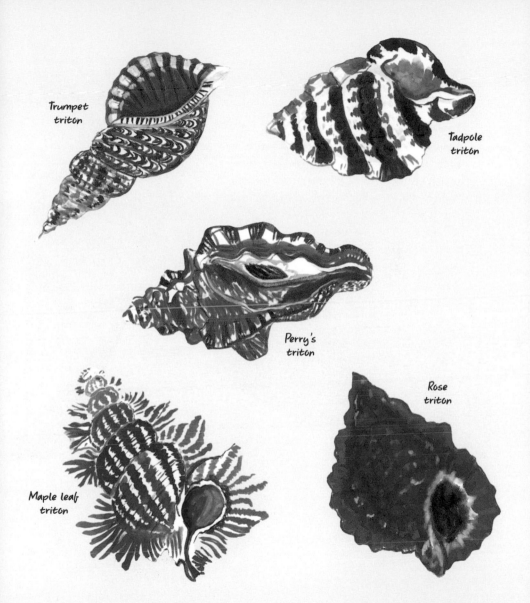

Trumpet triton

Tadpole triton

Perry's triton

Maple leaf triton

Rose triton

Harp Shells

There are only a handful of species in the beautiful harp family, whose shapes and stripes resemble the instrument. They are among the most colorful and patterned shells and are therefore highly prized by collectors. Harps have an ingenious survival adaptation: They're able to break away from part of their foot in order to escape quickly from predators.

Dennison's morum

True harp

Harp

Articulate harp

Ventral harp

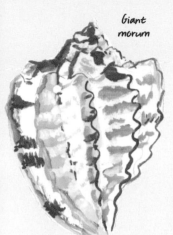

Giant
morum

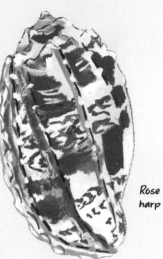

Rose
harp

Major
harp

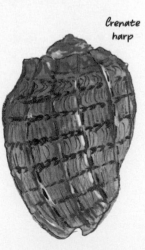

Crenate
harp

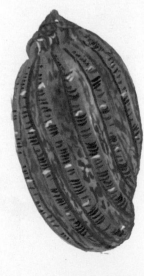

Minor
harp

Screw Shells

Screw shells can grow up to five inches in length, relatively large for a gastropod.

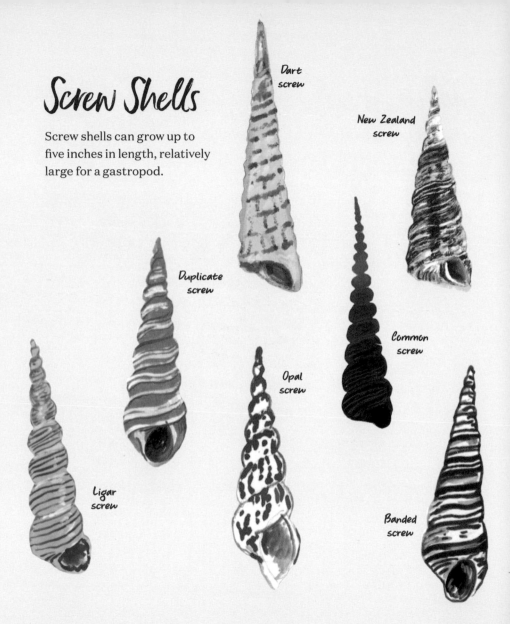

Dart screw

New Zealand screw

Duplicate screw

Opal screw

Common screw

Ligar screw

Banded screw

Tulip Shells

Delicate like a flower? Think again. Tulip shells only resemble the flower in shape. These large predators (sometimes as big as nine inches!) are venomous and can sting humans if disturbed.

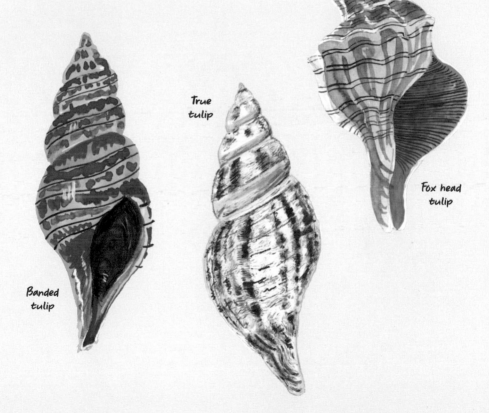

True tulip

Fox head tulip

Banded tulip

Vase Shells

Gastropods in this family are often relatively large, with thick shells. Most of the time they are conical in shape with an open aperture resembling a vase.

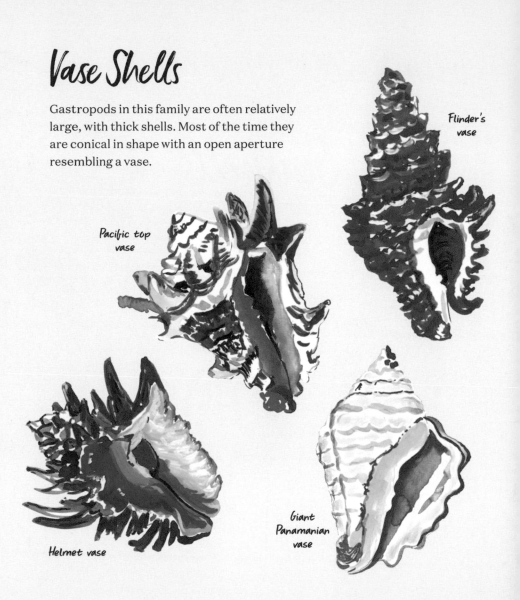

Flinder's vase

Pacific top vase

Helmet vase

Giant Panamanian vase

Seashells

ALEXANDER POSEY (1910)

I picked up shells with ruby lips
That spoke in whispers of the sea,
Upon a time, and watched the ships,
On white wings, sail away to sea.

The ships I saw go out that day
Live misty—dim in memory;
But still I hear, from far away,
The blue waves breaking ceaselessly.

Drupe Shells

The shells in this family resemble their namesake—a drupe is a fruit with a fleshy exterior and a single large pit inside (for example, peaches and plums)—with their considerable aperture and thick, round body whorls.

Lobate drupe

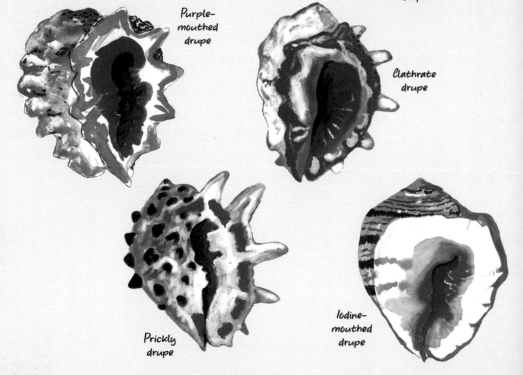

Purple-mouthed drupe

Clathrate drupe

Prickly drupe

Iodine-mouthed drupe

Bonnet & Helmet Shells

The common names for these large, heavy shells come from their resemblance to the two types of head coverings. They often have a shield-like inner lip and a thick outer lip covered in teeth. Early mariners used these strong shells to carve out canoes.

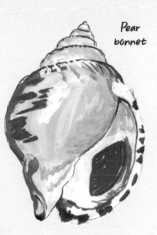

Pear bonnet

Striped bonnet

Checkered bonnet

Bull's mouth helmet

Mediterranean bonnet

Clams

Most giant clams grow to be around four feet in length and can weigh more than five hundred pounds. Giant clams can also have giant pearls inside. Depending on size, these could be valued at roughly $90,000, but it's rare to find such a pearl.

Giant clam

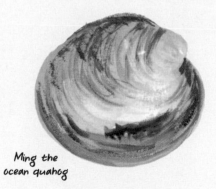

Ming the ocean quahog

The longest-living animal in recorded history was a 507-year-old clam. Ming, an ocean quahog, was named after the Ming Dynasty, the time period in which this bivalve was born.

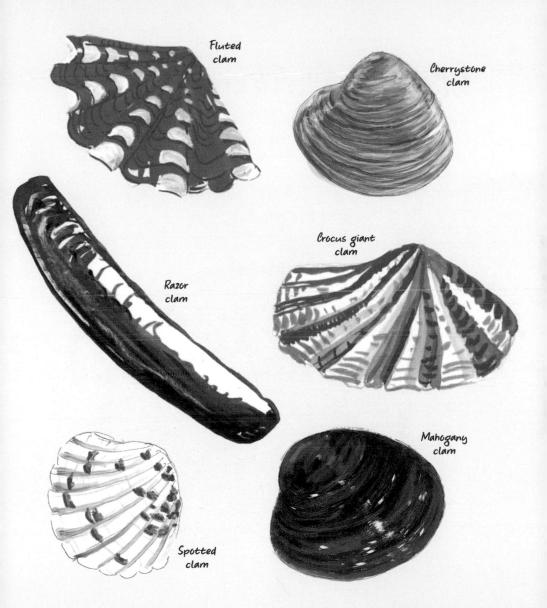

Fluted clam

Cherrystone clam

Razor clam

Crocus giant clam

Mahogany clam

Spotted clam

What's on the Menu?

Moules-frites, or "mussels and fries," is a dish commonly found in Belgium, the Netherlands, and northern France. Usually served with mayonnaise on the side, the shellfish is cooked with white wine, shallots, and butter. The french fries are perfect for soaking up the extra sauce. And don't forget—never eat a closed mussel!

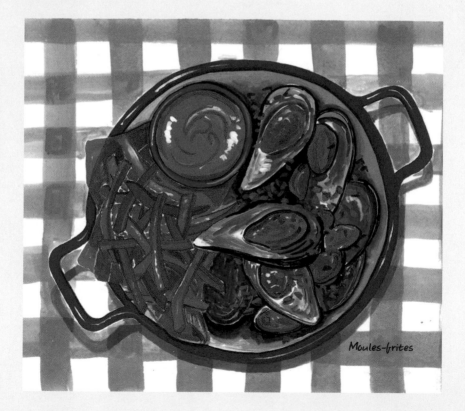

Moules-frites

Usually served atop crushed ice, raw oysters should be eaten freshly shucked. They are best slurped right from their shell with some cocktail sauce, mignonette sauce, and a squirt of lemon juice.

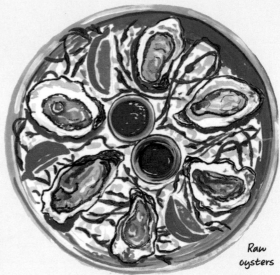

Raw oysters

Conchigliette

A shell-shaped pasta that literally translates to "little shell."

Thick, rich, and comforting, New England clam chowder was introduced to the region by French settlers and became a common dish by the early eighteenth century. It's often served with oyster crackers.

New England clam chowder

Conch, which is readily available in the Caribbean, is a popular food on the islands. Conch salad is made with chopped tomatoes, bell peppers, onions, and habanero and dressed with orange and lime juice.

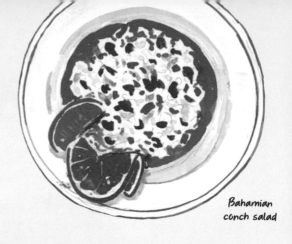

Bahamian conch salad

Bai Top, or canned whelk, is a pantry staple in Korea, where it is used in salads, stews, and rice dishes.

Oyster po'boy

Korean canned Bai Top

The po'boy ("poor boy") sandwich originated in New Orleans in 1929 during a streetcar strike. Martin Brothers' French Market gave free sandwiches to the picketing streetcar workers.

Thieboudienne

Senegal's national dish, thieboudienne, includes yete (fermented sea snails). The mollusks are buried in the sand for several days and then dried in the sun before being used in the dish.

Manhattan clam chowder

Canned oysters have a very particular briny taste and "smushy" texture. They are delicious smeared on crackers.

Canned oysters

This tomato-based soup emerged in the mid-eighteenth century, influenced by the Italian immigrants and people from Portuguese fishing communities in Rhode Island who came to New York City's Fulton Fish Market.

A popular dish from the coastal city of Mangalore, India, the clams are cooked in a spicy coconut masala.

Clam Sukkah

Mussels

Mussels have been consumed by humans for more than twenty thousand years—so long that some scientists believe these bivalves were critical to early brain development. Mussel "beards," which the creatures use to attach themselves to rocks, are so strong that scientists are developing a mussel-based surgical adhesive.

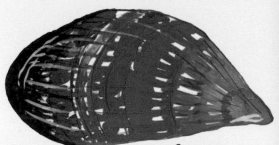

Black-ribbed mussel

Blue mussel

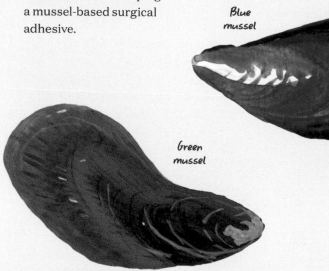

Green mussel

Cockles

Oysters may be a well-known aphrodisiac, but what's more romantic than nature's very own valentine: a heart-shaped shell.

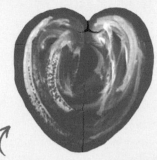

True heart cockles

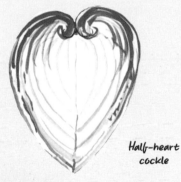

Half-heart cockle

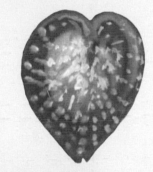

Maroon cockle

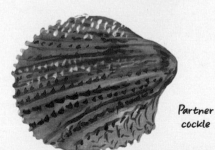

Partner cockle

Will You Be My Valentine?

You may have seen octagonal boxes with intricate shells designs in antique shops or in beach-themed stores. Known as sailor's valentines, these Victorian creations come with their own romantic mythology. Most people assume that sailors themselves crafted these gifts for their sweethearts with seashells they foraged after a hard day's work on their ship. In reality, most of these "valentines" were bought from women artisans between 1820 and 1890 in Barbados to be gifted to loved ones back home.

During this period, shell craft was all the rage, and dolls with clothes made out of or decorated with seashells were very popular. Women either bought these souvenirs from beach shops or collected their own shells when visiting the seashore to sew and glue to dolls' clothes upon their return home.

Bubble Shells

Bubble shells are so named because they are inflated and round. Their shell is very thin and delicate, and they are found in all oceans, particularly in shallow-water seagrass areas of the tropics.

Zoned paper bubble

White-banded bubble

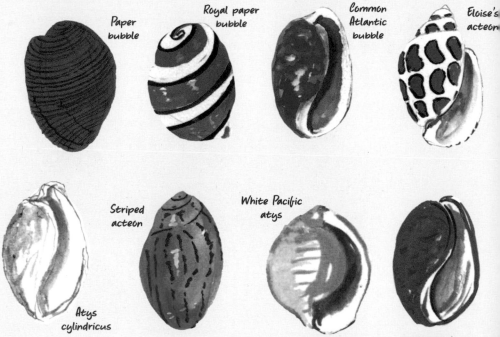

Paper bubble

Royal paper bubble

Common Atlantic bubble

Eloise's acteon

Atys cylindricus

Striped acteon

White Pacific atys

Mabille's bubble

Spindle Shells

Spindle shells live on sandy ocean floors and travel in pairs. The largest of these shells grows to be around nine inches long and is highly collectible.

Capart's spindle

Nicobar spindle

Wavy spindle

Sicilian spindle

Turban Shells

These shells belong to the Turbinidae family. The name comes from the Latin prefix "turbo," which means "spinning top" (it's not difficult to see the similarities!).

Heavy turban

Vintage spinning top

Green ridged turban

The South African turban shell is known for its shiny, pearlized beauty. However, the shell in its natural state is dull and quite unattractive. Only once the outer layers are cleaned and polished by grinding away the surface debris does this shell truly sparkle.

From this to this

South African turban

Tapestry turban

Cabinets of Curiosities

As Europeans explored and colonized during the fifteenth and sixteenth centuries, they returned with shells from the shores of Asia, Africa, and the Americas. Collectors were drawn to the diversity and beauty of the seashells. They displayed these treasures in rooms or cabinets designed to show off their wealth and worldliness. Shells were also gilded in expensive metals and turned into fancy showpieces.

Seventeenth-century footed nautilus cup, used for drinking on special occasions

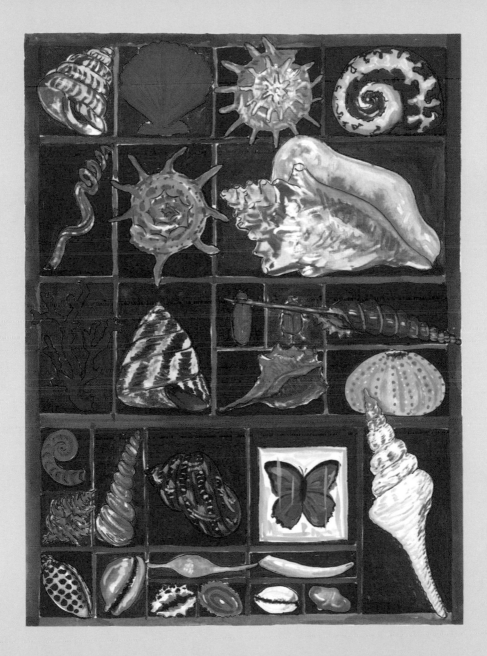

Cone Shells

For more than two centuries, the "Glory of the Sea" was the costliest and most desired shell in the world. The animal makes its home deep on the seafloor of the Pacific and Indian Oceans, making it difficult to find and collect its shell. In the eighteenth century, a *Conus gloriamaris* (Latin for "glory of the sea") was auctioned for three times the price paid for the Vermeer painting *Woman in Blue Reading a Letter* that same year. It is also, notably, the only seashell to ever have been stolen from a museum.

Conchylomania—the shell-collecting craze that took hold of Europe from the sixteenth to eighteenth centuries—reached its peak in the Netherlands during the Dutch Golden Age, around the same time as the infamous tulip bubble. Observing the madness take hold of a family member in 1782, Jean-Jacques Rousseau wrote that "his lively imagination saw nothing but shells in the natural world, and he . . . believed that the universe consisted of nothing but shells."

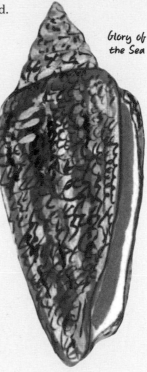

Glory of the Sea

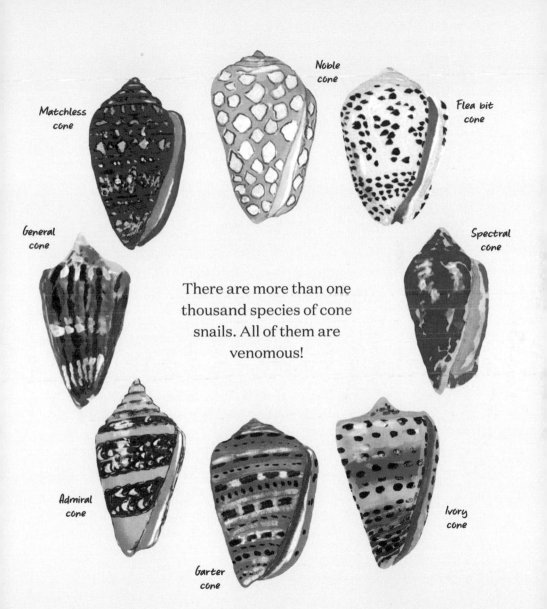

Matchless cone

Noble cone

Flea bit cone

General cone

Spectral cone

There are more than one thousand species of cone snails. All of them are venomous!

Admiral cone

Garter cone

Ivory cone

Latiaxis Shells

Exquisitely beautiful and delicate, latiaxis prefer deeper waters and do not possess a radula. Instead, these snails often have a parasitic relationship with sea anemones and similar marine creatures.

Teremachi's latiaxis

Pear-shaped coral snail

Fearnley's coral snail

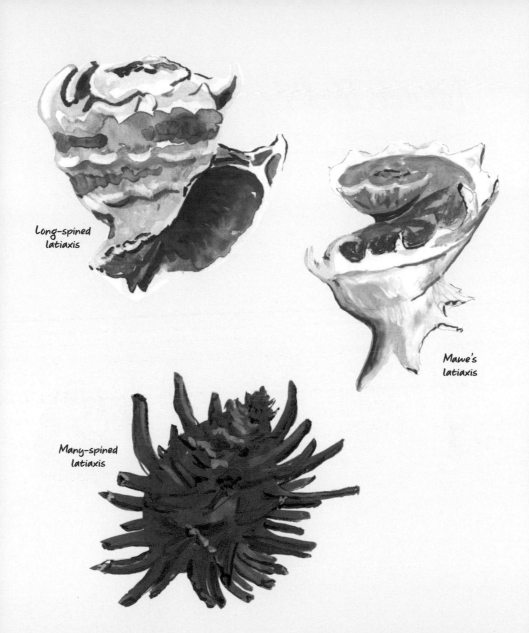

Long-spined
latiaxis

Mawe's
latiaxis

Many-spined
latiaxis

Star Shells

These awe-inspiring shells are defined by their protruding spines that jut out in a burst-like pattern.

Triumphant star turban

Glorious star

Not to be confused with starfish or shell stars

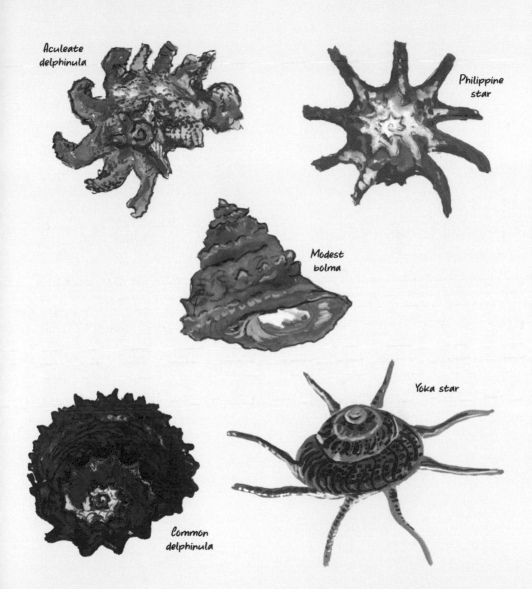

Aculeate delphinula

Philippine star

Modest bolma

Yoka star

Common delphinula

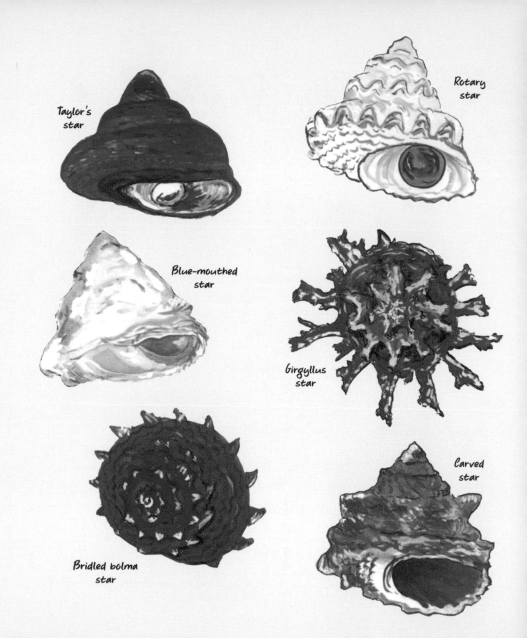

Taylor's
star

Rotary
star

Blue-mouthed
star

Girgyllus
star

Bridled bolma
star

Carved
star

Sea-Shells

EDITH NESBIT (1922)

I gathered shells upon the sand,
Each shell a little perfect thing,
So frail, yet potent to withstand
The mountain-waves' wild buffeting.

Through storms no ship could dare to brave
The little shells float lightly, save
All that they might have lost of fine
Shape and soft colour crystalline.

Yet I amid the world's wild surge
Doubt if my soul can face the strife,
The waves of circumstance that urge
That slight ship on the rocks of life.
O soul, be brave, for He who saves
The frail shell in the giant waves,
Will bring thy puny bark to land
Safe in the hollow of His hand.

Cowrie Shells

Because they are relatively common and easily portable, cowrie (or cowry) shells have been used in jewelry and as currency for thousands of years. The classical Chinese character for money has its origins in a drawing of a Maldivian cowrie shell.

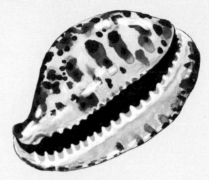

The word *porcelain* comes from the Old Italian term for cowrie shell, *porcellana*, because of the shiny quality of the shell's exterior.

Zigzag cowrie

Money cowrie

Golden cowrie

Tahitian gold ringed cowrie

Treble-spotted cowrie

Atlantic deer cowrie

Sieve cowrie

Checkerboard cowrie

Dark onyx cowrie

Teulère's cowrie

Agate cowrie

Onyx cowrie

Shells and Slavery

In the seventeenth through nineteenth centuries, enslaved peoples in the Americas died at much higher rates than free whites. This was especially true on coastal rice plantations in South Carolina, Georgia, and Louisiana, where conditions were swampy and the work was arduous, and on sugar plantations across the Caribbean. With enslaved peoples having come from diverse cultures and religions, there was no one "typical" burial practice. However, enslaved peoples in coastal areas often used seashells as grave markers or grave ornamentation. It's speculated that this sort of decoration came from burial rituals in Africa, where grave goods were seen as a means of guiding the dead's spirit to the ancestor world. Others explain it as a way for the enslaved to honor the sea and origins across the Atlantic.

> **The sea brought us, the sea shall take us back. So the shells upon our graves stand for water, the means of glory and the land of demise.**
>
> —*Gullah proverb*

Gravestone with seashells

Although cowries were used as money throughout the Indo-Pacific world, it wasn't until the sixteenth century that cowries were introduced as an important European currency; this began with the Portuguese, who used the shells in their booming trade with West Africa. Cowrie shells were exchanged directly for enslaved people, who, with the expansion of slavery throughout the Atlantic world and the development of a biology- and race-based system of subordination, were almost exclusively men, women, and children of West African descent.

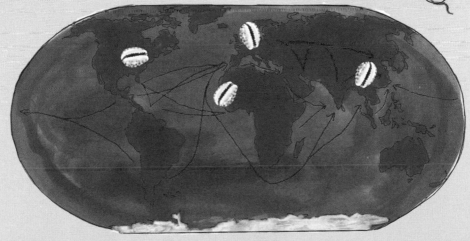

Cowries were often haphazardly strung together for transport and exchange.

Map of cowrie and slave trades

Nerite Shells

Presumably because this family of shells is relatively common, they are usually of little interest to collectors despite the vibrant colors and patterns on some of the species.

Emerald nerite

Wide nerite

Rough nerite

Bleeding tooth nerite

Snakeskin nerite

Red pheasant nerite

Polished nerite

Lined nerite

Candy nerite

Ox-palate nerite

Fig Shells

Fig shells are shaped like the eponymous fruit and have seemingly delicate, thin shells that are not easily broken. There are few species within this family of shells, and they are only found in sandy areas in tropical seas.

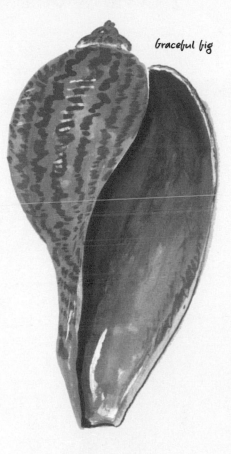

Graceful fig

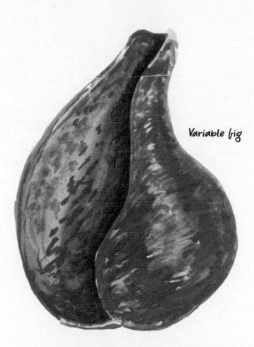

Variable fig

Sundial Shells

Sundial shells are usually flat and disc-like in shape, which allows the animal to float in the water. In some cultures, sundial shells are associated with time, balance, and harmony due to their perfectly round spirals.

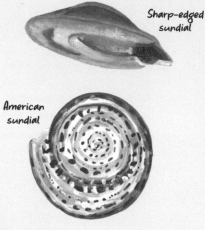

Sharp-edged sundial

American sundial

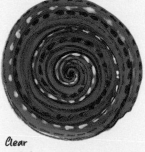

Clear sundial

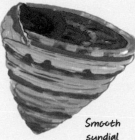

Smooth sundial

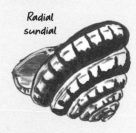

Radial sundial

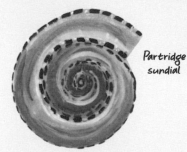

Partridge sundial

Straw sundial

Spirals in Nature

For thousands of years, people have looked to certain spiral shells as proof of nature's perfection. Painter Albrecht Dürer was the first to describe this logarithmic spiral as "eternal," in 1525. More than a century later, philosopher René Descartes pondered the equiangular spiral found in nature. But no one was more obsessed than Jacob Bernoulli, a mathematician who penned a treatise on the subject that he called "Spira Mirabilis" (the Miraculous Spiral). With this kind of spiral, he explained, the size increases but the shape remains exactly the same. The nautilus shell is a perfect example of a "miraculous spiral."

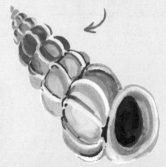

Spiral galaxy

The wentletrap shell grows logarithmically, with each successive coil expanding in size while maintaining the same shape at a constant rate.

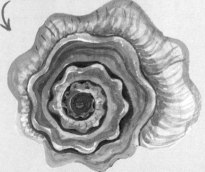

View of conch shell from above

Chambered Nautilus

Nautiluses provide a living link to the ancient past. They've been around some 480 million years, predating dinosaurs. When the shell of a chambered nautilus is cut crosswise, the nacred inner shell is revealed to display an almost-perfect equiangular spiral. The animal inhabits only the outermost chamber of the shell. The other chambers are filled with gas, which helps the animal float and hover in the water.

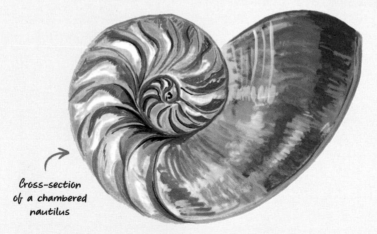

Cross-section of a chambered nautilus

Excerpt from

The Chambered Nautilus

OLIVER WENDELL HOLMES SR. (1858)

Year after year beheld the silent toil
That spread his lustrous coil;
Still, as the spiral grew,
He left the past year's dwelling for the new,
Stole with soft step its shining archway through,
Built up its idle door,
Stretched in his last-found home, and knew the old no more . . .

Build thee more stately mansions, O my soul,
As the swift seasons roll!
Leave thy low-vaulted past!
Let each new temple, nobler than the last,
Shut thee from heaven with a dome more vast,
Till thou at length art free,
Leaving thine outgrown shell by life's unresting sea

Shell Shapes

Architects have looked to shells for inspiration since antiquity. The *shell structure*—an actual architectural term—was invented in the 1920s. It refers to a thin, curved plate, and became popular after World War II.

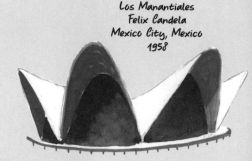

Los Manantiales
Felix Candela
Mexico City, Mexico
1958

TWA Flight Center
Eero Saarinen
Queens, New York, USA
1962

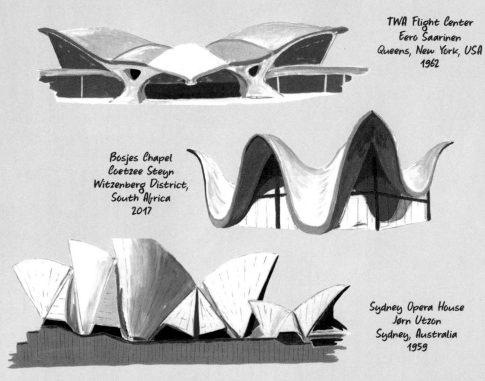

Bosjes Chapel
Coetzee Steyn
Witzenberg District,
South Africa
2017

Sydney Opera House
Jørn Utzon
Sydney, Australia
1959

The nautilus shell, specifically, has influenced structural design throughout history. Stand at the top of one of these staircases and look down. You may just feel like a snail in its shell.

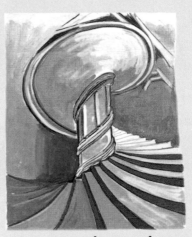

Spiral staircase, Chateau de Chambord
Leonardo da Vinci
Chambord, France
1516

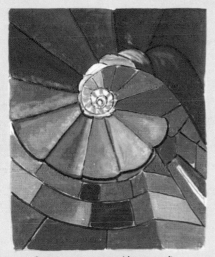

Spiral staircase in Nativity Tower,
Sagrada Familia
Antoni Gaudi
Barcelona, Spain
1882

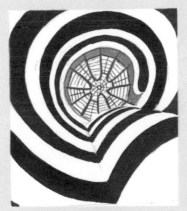

Guggenheim Museum
Frank Lloyd Wright
New York, New York, USA
1959

Turrid Shells

Turrid shells have great variety in their shape and structure. The identification of this family comes down to the sinus (or anal notch) at the top of the shell's outer lip.

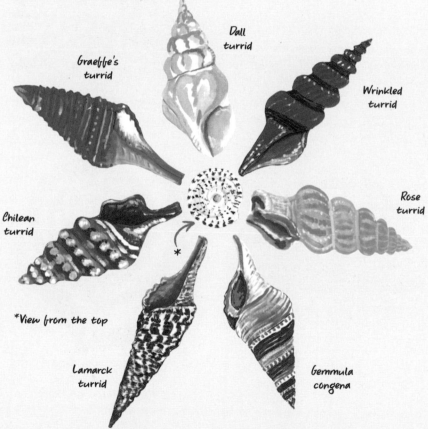

Dall turrid

Graeffe's turrid

Wrinkled turrid

Chilean turrid

Rose turrid

*View from the top

Lamarck turrid

Gemmula congena

Abalone Shells

Abalones are a type of bivalve, resembling a clam. The largest abalones grow up to twelve inches long. The animal has a large, strong foot that clings onto rocks. The abalone draws in seawater, and after passing over its gills, the water is filtered out through the line of natural holes along its shell. Abalone shells are prized for their iridescent beauty and can be found in beach shops throughout the world.

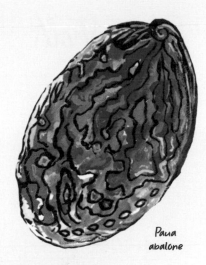

Paua abalone

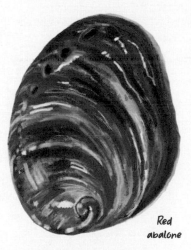

Red abalone

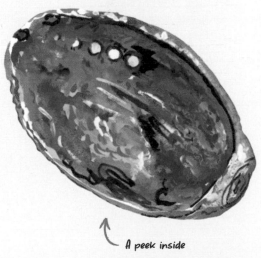

A peek inside

Auger Shells

Named after the shell's resemblance to an auger, a large drilling tool with a helical bit, these shells have high spires. Unlike most other highly glossy shells, auger shells are not covered with a periostracum, or thin outer coating.

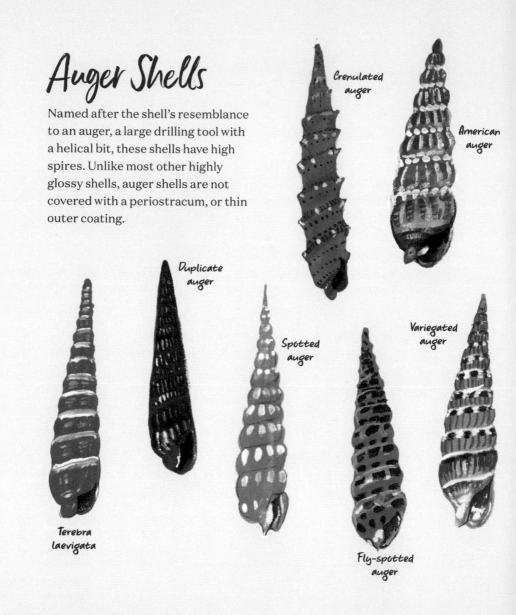

Crenulated auger

American auger

Duplicate auger

Spotted auger

Variegated auger

Terebra laevigata

Fly-spotted auger

Noble Pen Shell

Growing up to four feet in length, this large Mediterranean clam produces long, silky byssus (or fibers) to attach itself to the seabed. These filaments were collected by humans for hundreds of years to weave into a rare and valuable fabric known as sea silk that, when treated with lemon juice, turns a vibrant golden color. Sea silk was used by ancient Egyptians to wrap mummies and was traditionally a fabric only nobility could afford.

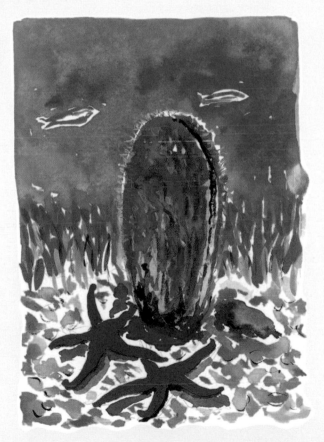

Rococo

Rococo is an elaborately ornate style of art, architecture, and décor of the eighteenth century. *Rococo* comes from the French word *rocaille*, meaning "broken shells." The curves and twists of this style mimic the forms of seashells, a motif found in objects small and large.

Grotto wooden chair

Gilded side table

Venetian shell bed

Just as mollusks carry their homes on their backs, during the rococo period, ornamentation became form.

Ornate silver spoon

Porcelain candlestick

In the late seventeenth and eighteenth centuries, garden follies decorated with shells became popular among the wealthy. These structures had no purpose beyond decoration, and the shell motifs demonstrated the glorification of and mastery over nature.

Garden folly

Art Deco

From the late 1920s through the 1930s, a new aesthetic took hold: art deco. Despite its insistence on modernity and progress, art deco design often drew inspiration from organic forms in nature. These motifs were then pared down and simplified, resulting in clean lines and shapes. One of the most popular patterns during this period was the repeating shell motif, which was commonly seen on wallpaper and carved into moldings.

Wall sconces

Wood buffet c. 1930

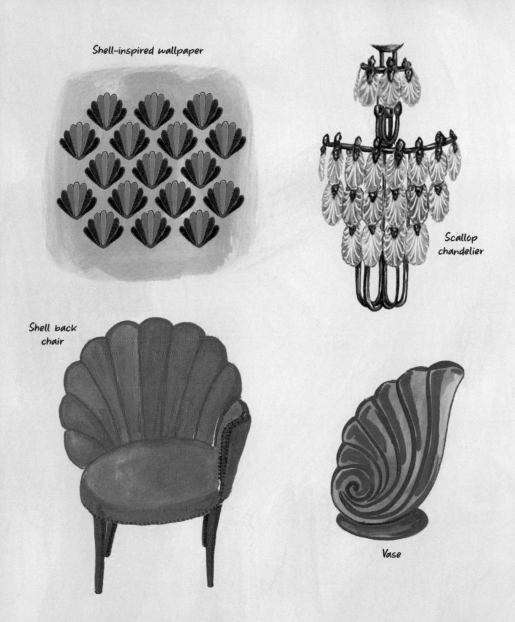

Shell-inspired wallpaper

Scallop chandelier

Shell back chair

Vase

Carrier Shells

Carrier shells do just what their name implies—
they collect and attach foreign objects to
the edge of their shells as they grow. The
reason is unclear: Are they trying
to camouflage? Do these
additions increase shell
strength and serve
as protection? It's a
mystery!

Creeper Shells

A carrier shell would probably not pick up a creeper shell on account of its size—mud creepers can grow to around six inches long. They make their home on muddy shorelines and can be found laboriously lugging their heavy shells—or creeping—across the coastal floor.

Ebony
mud creeper

West African
mud creeper

Telescope
shell

Mud creeper

Worm Shells

These oddly shaped shells house worm
snails. Instead of producing a spire, this
animal inhabits a tubular chamber and the
shell grows in a haphazard manner around
the substrate on which it lives.

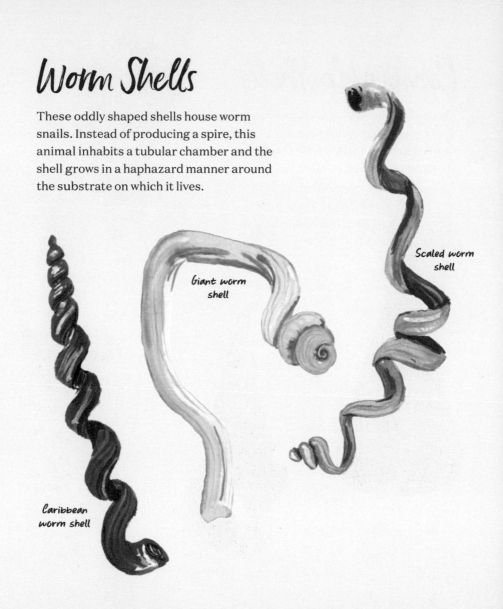

Scaled worm
shell

Giant worm
shell

Caribbean
worm shell

Periwinkle Shells

Also called winkles, these common snails are found in small pools on rocky beaches. They are edible and are delicious cooked in butter!

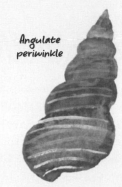

Angulate periwinkle

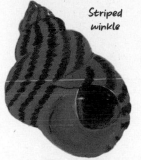

Striped winkle

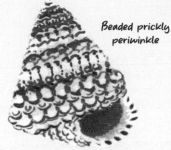

Beaded prickly periwinkle

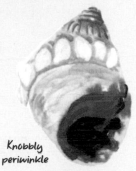

Knobbly periwinkle

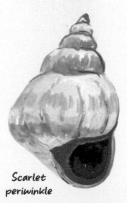

Scarlet periwinkle

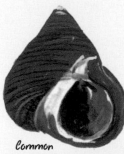

Common periwinkle

Dwarf winkle

Fashioning the Shell

What happens when fashion designers look to the sea? Unsurprisingly, seashells are usually seen on spring and summer runways. Certain brands, such as Alexander McQueen and Chanel, are inspired again and again by the seashell's form—the perfect seasonal option if you want to evoke the sea.

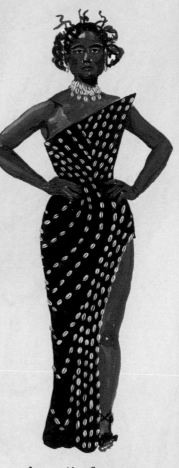

Actress Novi Brown in a gown of cowries made by Lafalaise Dion, 2022 BET Awards

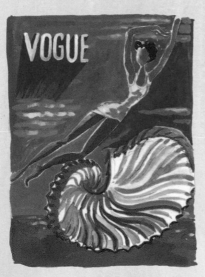

Vogue cover, July 1, 1937

Alexander McQueen Vogue
photo shoot, spring 2012

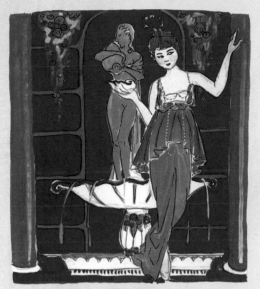

Jean Paquin gown,
fashion illustration by George Barbier,
1914

Alexander McQueen
mussel bodice,
spring/summer 2001

Chanel
seashell bag
2016

Scallops

Perhaps one of the most iconic shells, this bivalve has approximately sixty eyes on the surface of its body. Unlike other bivalve shells, the scallop cannot seal its shell shut and therefore resides in salty, deep-sea water to maintain constant moisture.

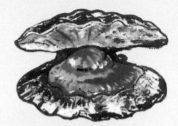

Royal cloak scallop

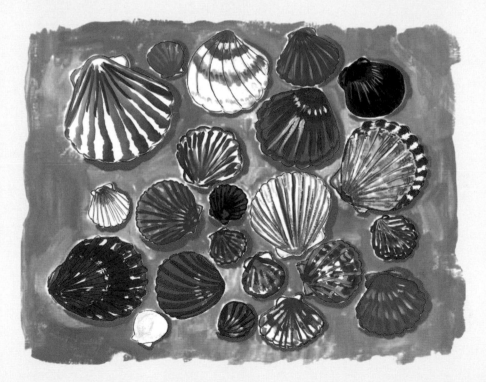

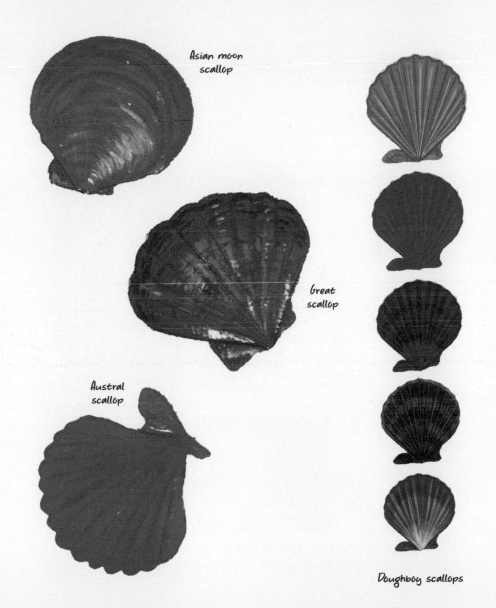

Asian moon
scallop

Great
scallop

Austral
scallop

Doughboy scallops

Invocation of the Seashell

In Hindu mythology, the god Vishnu is always depicted holding an Indian chank (or conch). The shell is symbolic of his victory over the evil demon Panchajana. This divine conch also resonates the sound of om, the original sound and vibration of the universe.

The Camino de Santiago is a network of pilgrimages in northwestern Spain that lead to the shrine of the apostle Saint James the Great. The scallop symbol marks these sacred routes, showing pilgrims the way. Scallops are associated with Saint James because after he drowned in a shipwreck, his body was washed ashore covered in scallops.

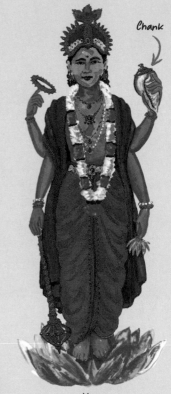

Chank

Vishnu

Pilgrimage marker

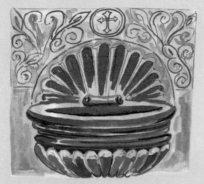

Scalloped baptismal font

Because scallops are a symbol of rebirth, baptismal fonts and the dishes used by priests to pour water are often shell-shaped.

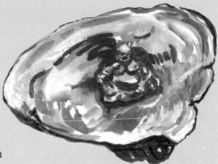

Chinese Buddha mabé pearl

The Chinese have been cultivating pearls for hundreds of years. They implant a form on the inner shell of a mussel and then return it to the water so that the mollusk can coat the shape in layers of pearl (tiny pearlized sculptures of Buddha were once popular). After several years they retrieve the treasure.

In Buddhism, the conch is one of eight auspicious Ashtamangala, or symbols, and its sound represents the voice of Buddha. It is believed that blowing the conch can boost positive vibrations of the mind, such as hope, optimism, willpower, and courage.

Tibetan Buddhist conch shell horn

Deep-Sea Snails

The scaly-foot gastropod, or sea pangolin, is only found in heated openings on the floor (hydrothermal vents) of the Indian Ocean. This snail is small but mighty. Living 1.5 miles underwater, it builds an outer layer of shell out of iron sulfide to resist the crushing pressure of the deep water and to protect itself from predators. The foot of the snail is also covered in armor, as the animal coats itself in jagged-looking iron scales—not so delectable to those who might try to eat it! Due to its iron coating, the scaly-foot gastropod is the only known animal with its own magnetic field.

Scaly-foot gastropod

Hydrothermal vents are cracks in the seabed that discharge extremely hot water due to the underlying magma. These vents can heat the surrounding water to a whopping 750°F. The sea pangolin's adaptations allow the creature to survive in these inhospitable conditions.

Gigantopelta chessoia is another deep-sea snail that lives in just a few hydrothermal vents near Antarctica. This gastropod undergoes a metamorphosis unlike any other. When the snail is small, it grazes for food like other animals. However, once it reaches a certain size, the snail's digestive system stops growing and its esophageal gland becomes enlarged, allowing bacteria to colonize there. From this point, it survives on the energy produced by the bacteria inside the snail's cells.

Gigantopelta chessoia

Elaphriella wareni, like many other deep-sea gastropods, lost its eyesight as it evolved, since it doesn't need it in the dark depths of the ocean. The eyes of this sea snail have been sealed over with external body tissue.

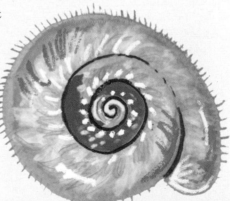

Elaphriella wareni

Shells in Pop Culture

In the classic young-adult novel *Lord of the Flies*, a conch shell is discovered and used as a horn to bring together a group of castaway boys stranded on a desert island. Throughout the book, the conch comes to symbolize law and order.

Early-edition cover of Lord of the Flies featuring conch horn

LORD of the FLIES

William Golding

In *The Little Mermaid*, Ursula the Sea Witch captures and stores Ariel's beautiful voice in the nautilus-shaped pendant she wears around her neck.

Ursula's shell necklace

In this famous beach scene in the 1959 comedy *Some Like It Hot*, Tony Curtis's character dresses up in nautical attire and wins over the character of Marilyn Monroe by saying that he is heir to the Shell Oil fortune, a fictional story inspired by a nearby basket of seashells.

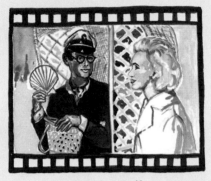

Some Like It Hot

Throughout history, mermaids have often been depicted topless. It's speculated that one of the first times they appeared wearing shell bras was in the 1953 film *Peter Pan*.

Mermaid wearing a
scallop-shell bra

Shell-Shocked

The shinbone tibia has one of the longest siphonal canals of all gastropods. This thin tube, which extends from the shell's mantle, is used like a straw to draw in water for feeding.

Shinbone
tibia

Instead of crawling slowly along the seabed, olive snails use their feet as surfboards, riding the waves to the shore's edge, where they then use their feet to catch prey.

With its flat-topped whorls, this shell is so unusual that when it was first discovered it was believed to be a disfigured shell instead of a whole new species.

Olive shell

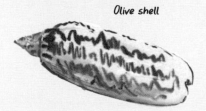

Japanese
wonder
shell

The Australian trumpet is the largest shelled gastropod. It can measure up to thirty-nine inches and weigh as much as forty pounds—about the size of a kindergartner! Can you imagine the vast trail of slime a snail this large might leave on the seabed?

Australian trumpet shell

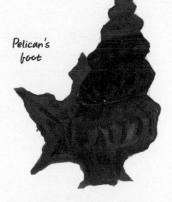

Pelican's foot

The three-pointed extension of this shell's outer lip looks like a pelican's webbed foot. The strange shape is believed to help the gastropod balance.

This delicate shell is one of a kind: Unlike the shells of other spiral gastropods, wentletrap whorls are not tightly joined together. In the eighteenth and nineteenth centuries, these shells were believed to be quite rare and were thus in high demand by collectors and worth a great deal of money—so much, in fact, that counterfeit wentletraps were made out of rice flour.

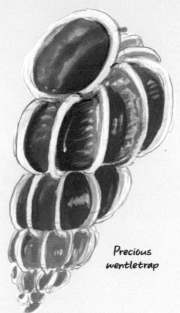

Precious wentletrap

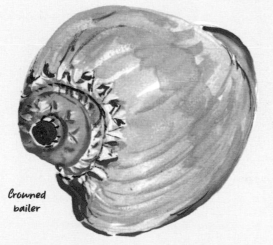

Crowned bailer

These shells are very round and can be up to a foot long. Crowned bailers are often used in Indonesia for carrying water or for bailing out canoes.

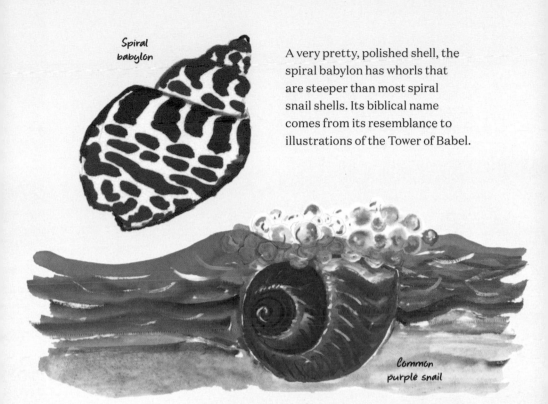

Spiral babylon

A very pretty, polished shell, the spiral babylon has whorls that are steeper than most spiral snail shells. Its biblical name comes from its resemblance to illustrations of the Tower of Babel.

Common purple snail

These snails are not only beautiful with their violet-blue hue, but they are also extremely resourceful! The snail's foot secretes mucus, which traps air bubbles and then hardens to create flotation devices, or "bubble rafts." The snails spend their whole lives floating on the surface of the sea on these rafts.

Excerpt from

The Sea Shell

WILLIAM WORDSWORTH (1814)

I have seen
A curious child, who dwelt upon a tract
Of inland ground, applying to his ear
The convolutions of a smooth-lipped shell;
To which, in silence hushed, his very soul
Listened intensely; and his countenance soon
Brightened with joy; for murmurings from within
Were heard, sonorous cadences! whereby,
To his belief, the monitor expressed
Mysterious union with its native sea.
Even such a shell the universe itself
Is to the ear of Faith: and there are times,
I doubt not, when to you it doth impart
Authentic tidings of invisible things;
Of ebb and flow and ever-during power;
And central peace, subsisting at the heart
Of endless agitation.

A Collector's Guide

Beachcombing is a fun and rewarding hobby. There are not many mollusks that live on the beach, but storms and waves push shells ashore once the animals have died. Three factors can influence the abundance of shells for collecting: the weather, the phases of the moon, and the tides. Here are some general tips:

1. Never take a live animal! If a shell is adhered to a substrate, even after a gentle wiggle, you can bet there's a happy snail inside, minding its own business. And never gather a closed or sealed bivalve because this means the shell still houses a mollusk.

2. Go right before or after low tide or during a full or new moon. More of the beach is exposed at this time, which will give you the best chance of finding treasures.

3. Hit the beach early in the morning, when only the most serious beachcombers are out.

4. Collect at night to avoid bright sunlight. Make sure to bring a light, and don't forget to turn over rocks to see what might be hiding underneath.

5. Wade into the water a foot or so. If you're really adventurous, dive down with a snorkel mask. Some of the most perfect and undamaged shells will be in deeper water.

6. Search for shells after a storm when the waters have been churned by wind and rain and new specimens have washed ashore.

7. Don't forget a mesh bag or pail to hold your haul.

Crafting with Shells

There are endless fun things to do with shells. Crafts can range from having a child paint a shell found on the beach to making a professional-level mosaic. Here are a few ideas:

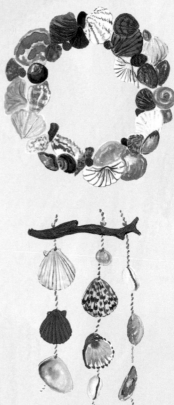

To make a lovely reminder of the beach for your door, take a foam wreath and loop some floral wire around the top to create a hanger. Hot-glue your seashells to the foam, making sure to overlap them and fill in any gaps where the base might show through.

Wind chimes can be created with a stick, string, seashells, and a small drill. Tie as many pieces of string as you want around the stick, which will hold your project together. Drill small holes in your seashells so that you can thread them like beads. Create knots along the string at the intervals at which you want your shells to hang. The closer each strand of thread is to another, the more "chimes" you'll hear.

A shell-shingled pot is an easy way to add some "beach" to your home if you have lots of scallop or other flat shells in your collection. Use a glue gun to adhere the shells to a pot or container—any material will work. Make sure to layer the shells in an upward fashion to make the most of the shell's shape.

The easiest way to make your own shell candles is to use a bivalve shell as the holder and a store-bought tea light as the candle material. Cut away the metal from the tea light and melt the wax in your shell.

Mirror frames made of seashells can seem daunting, but it's very easy to make one if you have enough shells and some time on your hands. Procure a cheap, framed mirror. The frame can be made of any material, but a flat wooden one will be the easiest to work with. Use a glue gun to stick your shells to the frame. Make sure to set aside a handful of small shells to stick into any nooks and crannies at the end. The same process can be used to create beautiful seashell picture frames.

Storing Your Shells

There are lots of tried-and-true methods for sorting and storing your seashell collection. Many collectors like to use segregated drawers, like antique printer trays. These can be labeled and lend themselves to a tidy display. Small shells can be organized in glass jars or vials, with labels adhered to the outside of the glass or put inside with the shells. Art storage bins can also be useful storage for your collection. Just remember to keep your shells away from direct sunlight and out of the dust and air. Don't touch them too often, as the oils on your fingers aren't good for shell preservation. And try to avoid storing your collection in acidic woods like ash, spruce, oak, or chestnut, as these can degrade the carbonate in the shells.

Once your collection is properly stored and organized, it will be easy to return to it whenever you need a reminder of the joys of the ocean. Let your tiny treasures bring you back to the shore and experience, once again, the wonderful anticipation of combing the beach in search of that perfect keepsake.

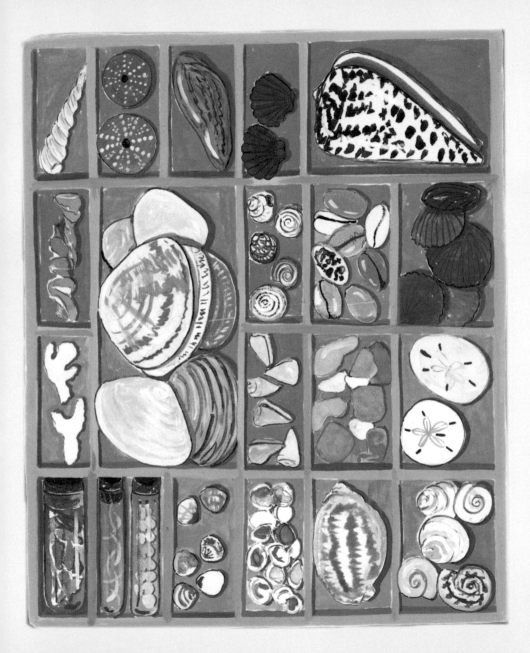

Acknowledgments

The return to making art has been a journey shepherded by my aunt and mentor, Robin Preiss Glasser. It was with her help and encouragement that I was able to carve a new path for myself after abandoning my PhD in early American history and the academic career that had been my goal for so long. "Auntie Orbit" helped retrain my hand to paint and draw and shared her vast knowledge with me, mostly from bed while she was recovering from cancer during the first isolating months of the pandemic. She has been my champion from the start, and I am so grateful for her love and support and mentorship.

I'm grateful to my editor, Rachael Mt. Pleasant, who dreamed up this book and worked with me every step of the way to make something beautiful. She has been patient and encouraging with me as I've navigated the world of publishing. Thank you to my agent, Nicole Cunningham, who I am so lucky to be working with. She, too, has held my hand and shown me the ropes as I've worked my way through this project. This endeavor has been quite the learning process, and I am in awe of the team at Workman Publishing, who has turned this concept into a reality. Sarah Smith, you a re so very talented and I am lucky to have benefited from your clarity of vision and design sense. Thank you also to Lisa Hollander who worked on this project in its early phase, setting it up for success. Thank you, Kimberly Ehart, Ivanka Perez, Cindy Lee, Elissa Santos, and Julie Primavera for your ingenuity and expertise.

I gained a love of history and dexterity with research during my time in graduate school. I am forever indebted to my adviser and friend, Kathleen M. Brown, who taught me to prod and question, and who never resented my changing aspirations as I became a wife and mother.

My friends are a constant source of humor and support. Thank you to Gena, who helped introduce me to the world of art-as-career. Your creativity continues to inspire me. Nani, the grace with which you balance work and family sets an example to which I aspire. Our walks and coffee-shop work dates sustain me. And Rachel, a true Renaissance woman, has been my sounding board for this project from the beginning. She is not only a true and loyal friend, but she is also a brilliant research assistant. Thank you.

I would be remiss not to thank our former nanny, Gabi, whose constant patience, care, and feeding of my brood helped me at the start of this project to focus on work beyond extracurricular schedules, tantrums, and cuddles.

It's hard for me to imagine how people write and illustrate a book without the 24/7 live-texting services offered by my mother. A book project can feel lonely sometimes. Thankfully my mother at least pretends to enjoy seeing every single thing I paint or write the second I finish it. And while a thirty-five-year-old woman should be able to accomplish tasks without the feedback and approval of her mother, I, unfortunately, need this constant source of affirmation.

To my husband and partner, Garrett: Thank you for letting me explore who I am and what I want to do with my life. I am so grateful for all the sacrifices you make for me—all the dishes you wash, the bedtimes you lead, and the mornings you wake up with the kids so that I can get a bit more sleep. I am so lucky to love a feminist who is happy to share in all the daily drudgery. Your strength, hard work, and fathering has allowed me to do what I love and discover a new career.

Ari, Oliver, and Madeline: Thank you for coming into my life and showing me that it's okay for dreams to change. You three are, and will always be, the lights of my life and my most important creations.

About the Author

Jessie King Regunberg is an artist and writer in Washington, DC, where she lives with her husband and three children. When Jessie is not schlepping said children to sports games and playdates and trying to satisfy their insatiable appetites, she can be found in her art studio painting with gouache or creating mosaics. Jessie trained as a historian but found her way back to art after the birth of her second child. She writes for adults and children and feels incredibly lucky to be making a career out of the things she loves most.

From the artist's collection: shells from Tulum, Mexico